ISBN 978-1-61584-170-7

The
BUTT BOOK
by
David Kirsch
(AKA Master of the Ass®)

Illustration by
Steve Wacksman

I'm David Kirsch

For the past twenty years I've been sculpting the best butts in the business.

Heidi Klum, Liv Tyler, Naomi Campbell, Linda Evangelista, Karolina Kurkova, Kerry Washington, Kim Raver, Anne Hathaway, Ellen Barkin…. they've all trusted me to get their bottoms pert and perky.

Now it's your turn.

I've written three books before, but this is a totally new kind of book for me—I'm going to talk to you just like I talk to the clients at my New York City gym. This is my personal training session with you, wherever you are.

We're going to get serious about your butt and we're going to have a great time doing it. Think of this book as your butt bible—I want you to toss it in your bag when you're going to the gym, or plop it near the sofa, right in the spot where you used to veg out (it can replace that bag of chips…). It's full of moves you can manage when you're home on a chilly night, or sitting behind your desk. The exercises are easy to follow, and they're completely portable.

Here's the thing: I've never

come across a butt I couldn't sculpt. I can make them higher, rounder, tighter, larger, smaller.

My training philosophy has always been to help YOU FIND YOUR BEST YOU! Young or old, model, housewife, CEO—you have a fabulous butt waiting for you.

Now let's go get it.

As with all of my programs, this is meant as a guide. Feel free to personalize it to suit your level of fitness and the equipment you have access to. So long as you're pushing yourself as hard as you can, adjust as needed. The most important thing is that you are never mentally disconnected from your body.

And don't bother cheating: you know the difference between getting sweaty and merely damp.

the ④ BODY TYPES

Big All Over
Claire

If you gain weight, it's a little here, a little there, a little everywhere. For you, follow the prescribed moves and never skip your cardio, and we'll reduce, tone, and tighten your way to a boomin' bottom.

TYPE 1 the apple ➤

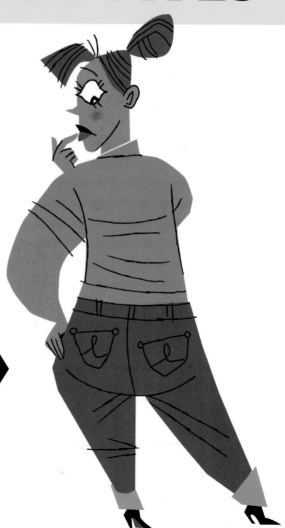

Bodies are like snowflakes: every one is unique. I've identified four general shapes, and most people can at least loosely identify with one. Each shape has different exercise and diet needs.

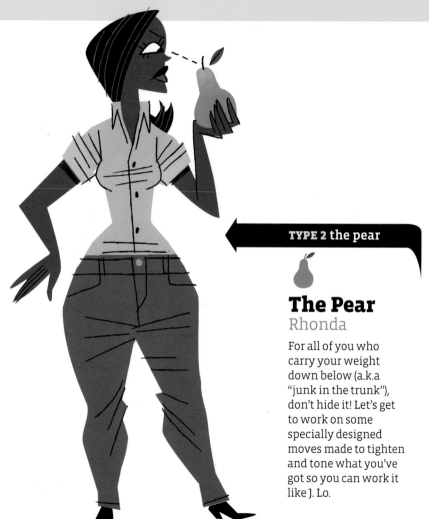

TYPE 2 the pear

The Pear
Rhonda

For all of you who carry your weight down below (a.k.a "junk in the trunk"), don't hide it! Let's get to work on some specially designed moves made to tighten and tone what you've got so you can work it like J. Lo.

the ④ BODY TYPES

TYPE 3 the banana

In search of a backside

Kristina

Ah, the dread "flat ass." You gain weight everywhere *but* your butt. For you ladies, the days of baggy sweaters is drawing to a close. Let's add volume, lift, and well-considered curve.

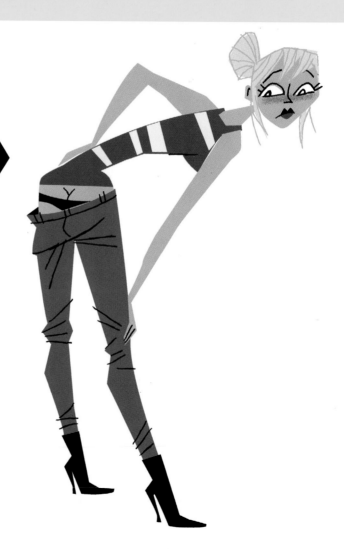

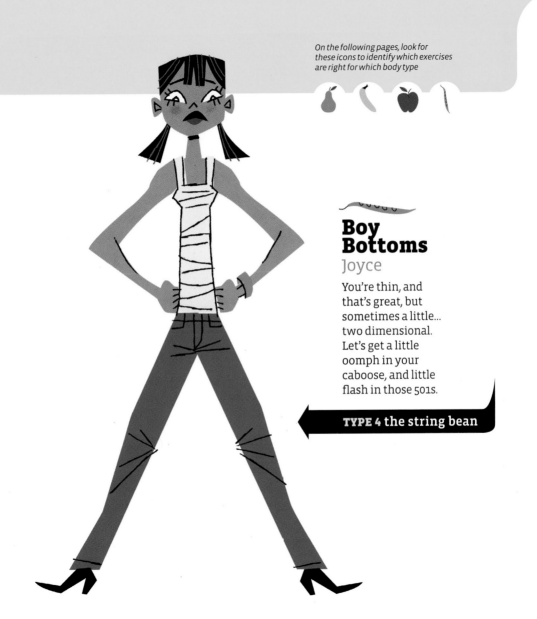

On the following pages, look for these icons to identify which exercises are right for which body type

Boy Bottoms
Joyce

You're thin, and that's great, but sometimes a little... two dimensional. Let's get a little oomph in your caboose, and little flash in those 501s.

TYPE 4 the string bean

9

2
the
EXERCISES

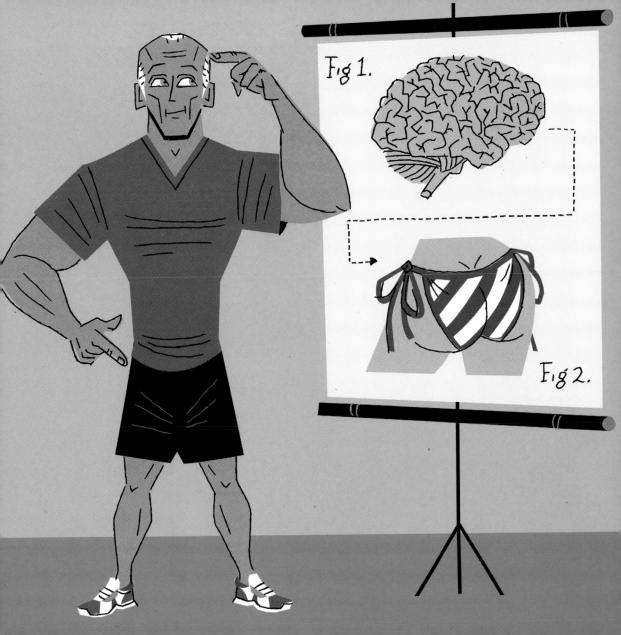

Fig 1.

Fig 2.

Put your brain in your butt...

I'm always telling my clients to put their brains in their butts. What I mean is focus your energy! If you pay attention to your body, you'll know when something's working.

On the following pages are a series of exercises designed to lift, firm, tone and tighten your bottom. Do these moves four times a week, and really think about your butt while you're doing them. Can you feel something happening down there?

Push yourself without hurting yourself. If anything causes severe discomfort, stop right away, and then call your doctor—not even a great butt is worth getting hurt for. There are six main concepts to exercise.

BODY MECHANICS: Get everything lined up correctly.

CONCENTRATION: Stay in the moment!

FLOW: Connect your movements to your breath.

VISUALIZATION: Picture yourself doing the most beautiful lunge, the perfect squat.

GAZE: This is an old ballerina trick, and it works. Where you look during an exercise can help keep you in line.

ATTITUDE: "I can't" is no longer part of your vocabulary.

My exercises are totally customizable. I've provided tips and modifications for stiff backs and bum knees: follow them if you need to.

Now, get ready to sweat.

1
Start upright, feet shoulder-width distance apart, hands behind your head.

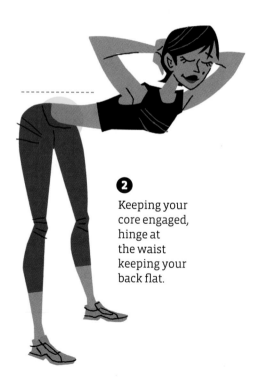

2
Keeping your core engaged, hinge at the waist keeping your back flat.

Wake up! Get your butt out of bed and get your brain down in it. A quick round of good mornings before your first cup of green tea will loosen your tight muscles up and get you ready for some major butt sculpting.

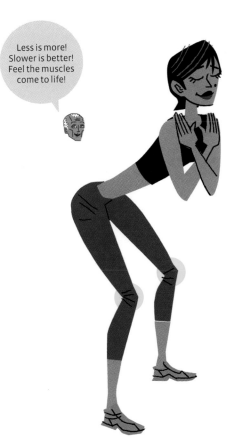

Less is more!
Slower is better!
Feel the muscles
come to life!

Modification
Cross your hands over your chest and bend your knees slightly, hinge only partially if you have problems with your lower back.

② SQUATS

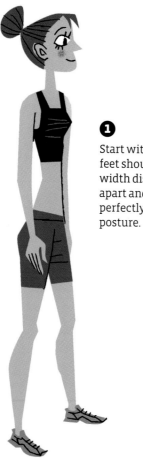

❶ Start with your feet shoulder-width distance apart and perfectly upright posture.

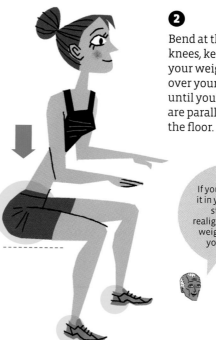

❷ Bend at the knees, keeping your weight over your heels until your thighs are parallel to the floor.

If you're feeling it in your quads, stop and realign—get your weight back to your heels.

The key to a successful squat is getting your brain in your backside. Concentrate on lifting through your heels—this will ensure maximum butt burn.

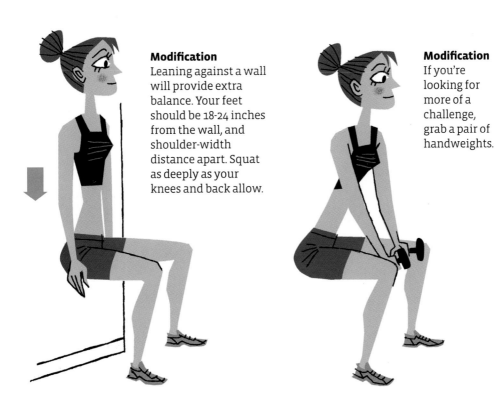

Modification
Leaning against a wall will provide extra balance. Your feet should be 18-24 inches from the wall, and shoulder-width distance apart. Squat as deeply as your knees and back allow.

Modification
If you're looking for more of a challenge, grab a pair of handweights.

② PLIÉ SQUATS

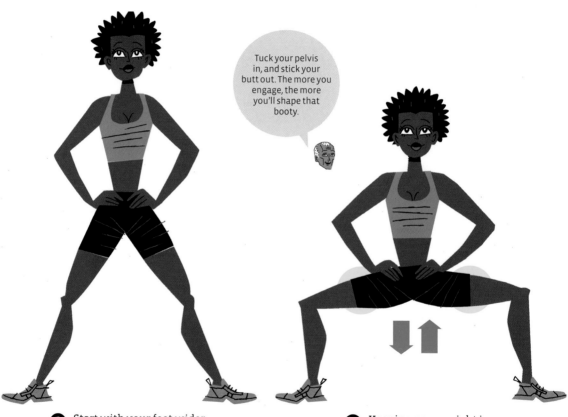

Tuck your pelvis in, and stick your butt out. The more you engage, the more you'll shape that booty.

❶ Start with your feet wider than shoulder-width distance and turn your toes out. Weight is still in your heels.

❷ Keeping your weight in your heels and your knees turned out, squat down and up.

Plié squats are particularly perfect for the pear shaped body. They really get your inner thighs working, and they're a full-scale assault on your lower butt. If you've already got a butt, these will shape it into something spectacular.

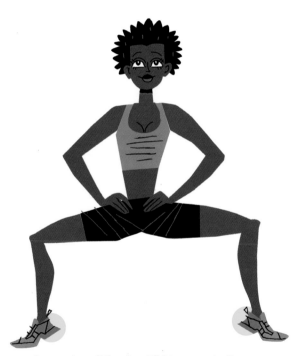

Advanced Modification *Plié toe squats.* Once you've mastered the plié squat, turn it up by lifting your heels up as you squat. This puts greater emphasis on your inner thighs, butt and core.

② LUNGES

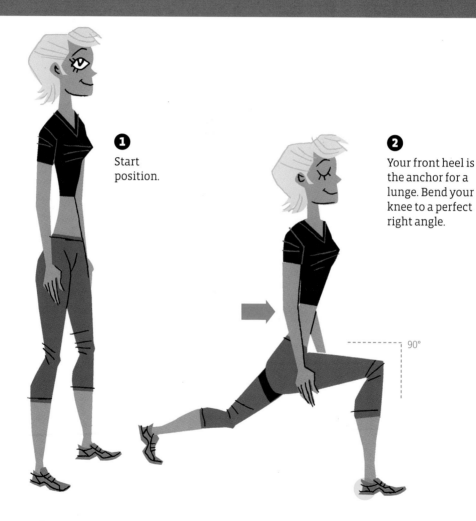

❶ Start position.

❷ Your front heel is the anchor for a lunge. Bend your knee to a perfect right angle.

90°

Lunges are the classic butt-shaping, sculpting exercise, and there are endless variations. First, though, you've got to m-ass-ter the classic.

The perfect lunge will give you two right angles. Do not allow your knee to pass your toes.

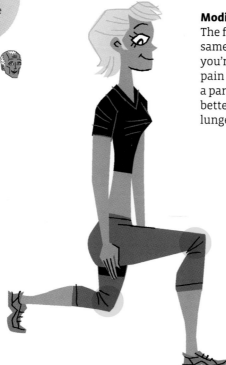

Modification
The form is the same, but if you're feeling pain in your knees, a partial lunge is better than no lunge at all.

② CROSSOVER LUNGES

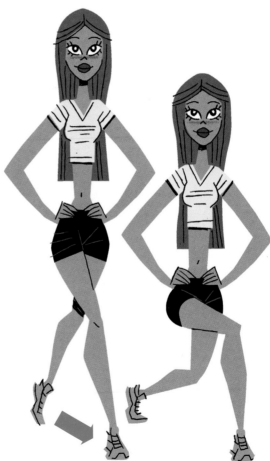

❶ Start upright, feet shoulder-width distance apart, hands on your hips.

❷ Start with your right leg. Step forward and cross over your left leg, while bending at the knee.

Perfect for shaping the outer part of the butt, crossover lunges are the enemy of saddlebags!

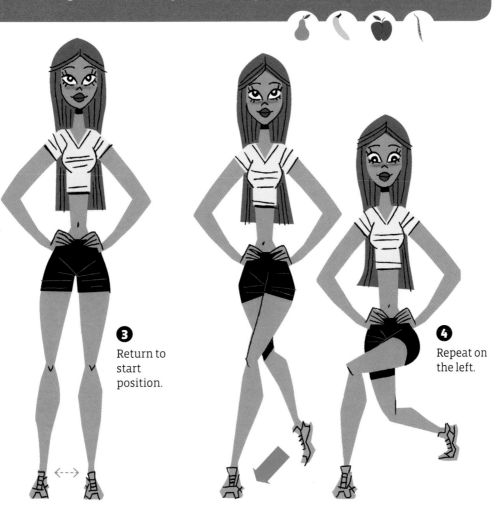

3 Return to start position.

4 Repeat on the left.

② LATERAL LUNGES

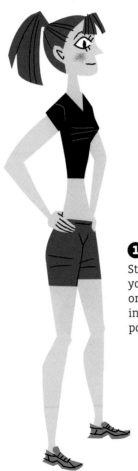

❶ Start with your hands on your hips in your start position.

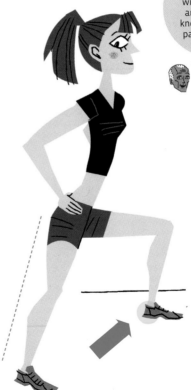

Make sure you're anchoring with your heel, and that your knee never goes past your toes.

❷ Step your left leg out to the side, landing on your heel, keeping your right leg totally straight.

This is another exercise good for all body types, and it's great for tightening inner thighs while toning your butt.

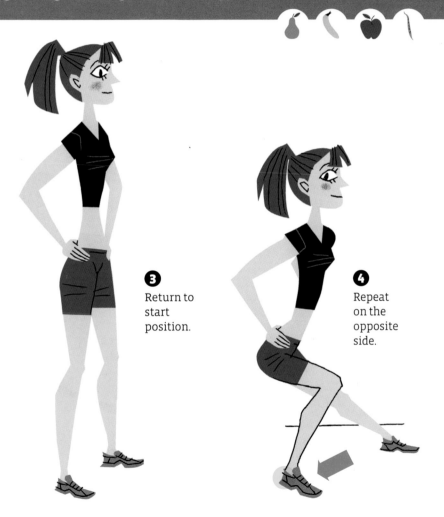

3 Return to start position.

4 Repeat on the opposite side.

② BENT LEG DEADLIFTS

❶ Holding a body bar, dumbbells, medicine ball (a broomstick or a baby will do in a pinch!) stand in your start position .

❷ Hinge at the waist. As you bend forward, soften your knees and stick your butt out.

As you bend, keep the energy in your butt, keep your core engaged, keep your back flat, and as you lift, pull your hips forward, contracting your glutes.

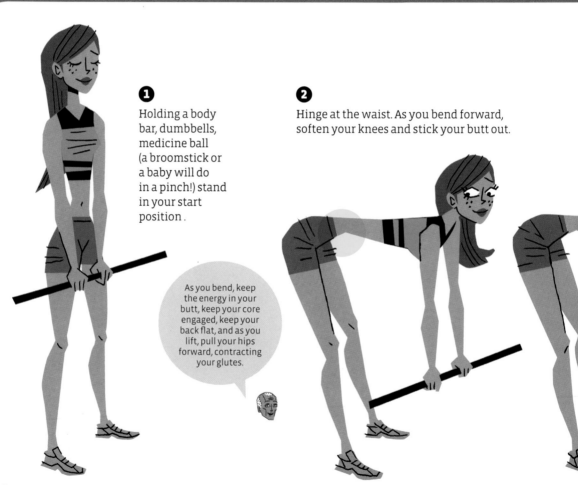

Unlike its close cousin The Good Morning, bent leg deadlifts really help lift and shape your bottom.

Modification If you're feeling shaky, hold the back of a chair or the edge of a table for balance.

Modification If you're feeling great, try lifting your alternate leg as you go down.

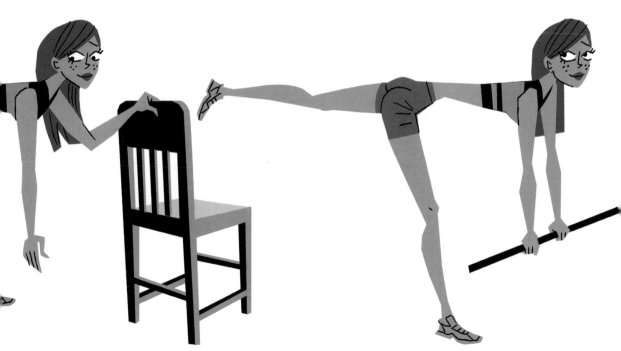

27

1
Start in a plié squat position, with your hands behind your head and your thighs parallel to the ground.

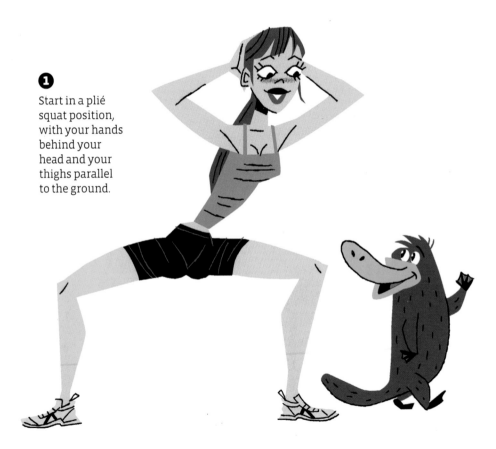

One of my signature moves, you're not going to look pretty doing it. The result, though...hot stuff!

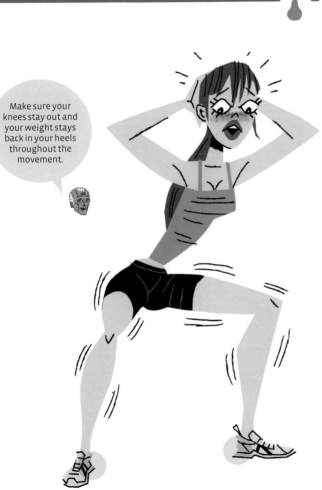

Make sure your knees stay out and your weight stays back in your heels throughout the movement.

❷ Waddle forward! Right foot in front of your left, stay engaged in that plié squat. Now reverse....

2 SUMO LUNGES

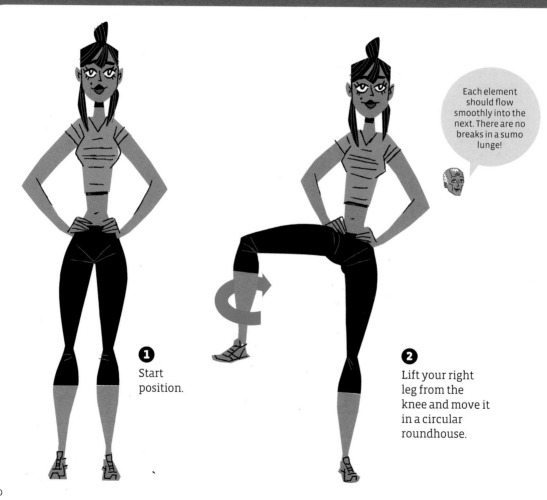

Each element should flow smoothly into the next. There are no breaks in a sumo lunge!

1 Start position.

2 Lift your right leg from the knee and move it in a circular roundhouse.

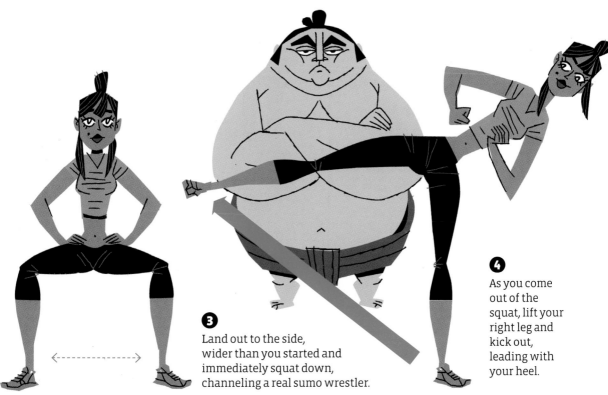

A perfect butt-shaping, hip reducing, lower half-sculpting maneuver! Done right, your butt will sing and your heart will scream.

3 Land out to the side, wider than you started and immediately squat down, channeling a real sumo wrestler.

4 As you come out of the squat, lift your right leg and kick out, leading with your heel.

31

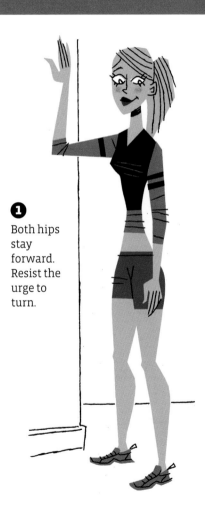

❶ Both hips stay forward. Resist the urge to turn.

This exercise demands focus. It is a basic, elementary exercise that can be scaled easily up or back, and it can be done absolutely anywhere.

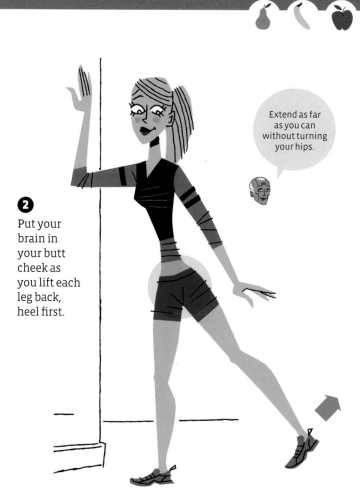

2 Put your brain in your butt cheek as you lift each leg back, heel first.

Extend as far as you can without turning your hips.

② DONKEY KICKS

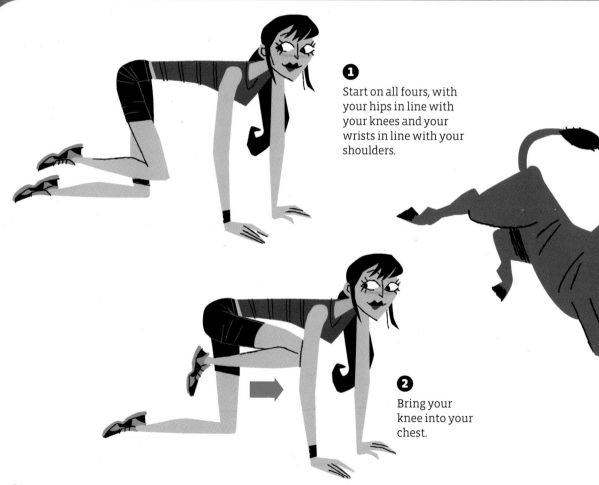

❶ Start on all fours, with your hips in line with your knees and your wrists in line with your shoulders.

❷ Bring your knee into your chest.

A basic high school gym exercise that really works!
I turn up the intensity of course to really round out the butt.

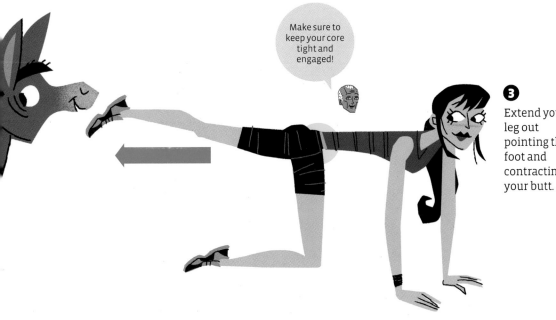

Make sure to keep your core tight and engaged!

3 Extend your leg out pointing the foot and contracting your butt.

② FROG JUMPS

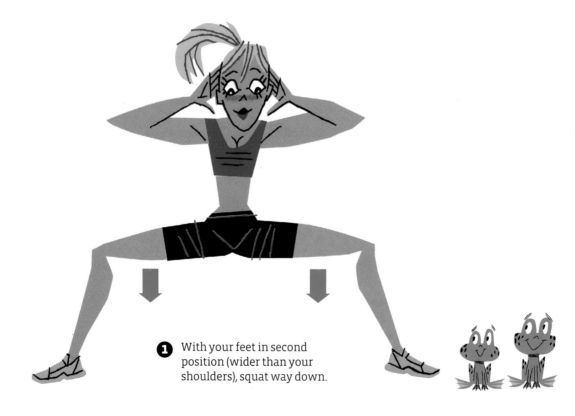

1 With your feet in second position (wider than your shoulders), squat way down.

36

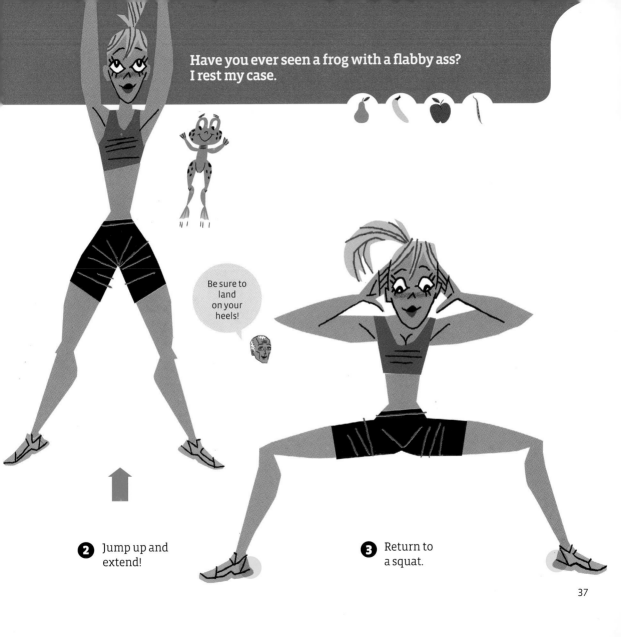

Have you ever seen a frog with a flabby ass?
I rest my case.

Be sure to land on your heels!

2 Jump up and extend!

3 Return to a squat.

1 With your hands wider than your shoulders, bring one foot in towards the chest, extending the other.

Babies have nice bottoms, right? Now lose the diaper and hit the floor for some crab crawls!

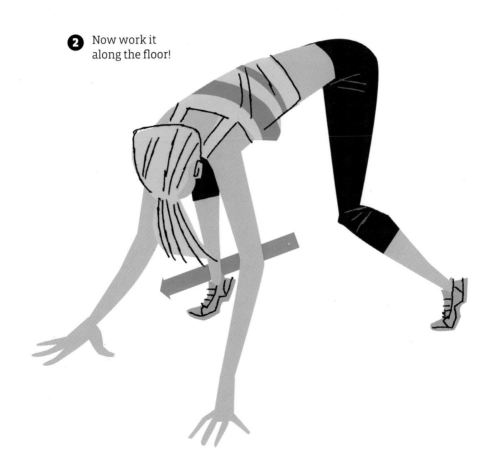

2 Now work it along the floor!

3
the
COMBOS

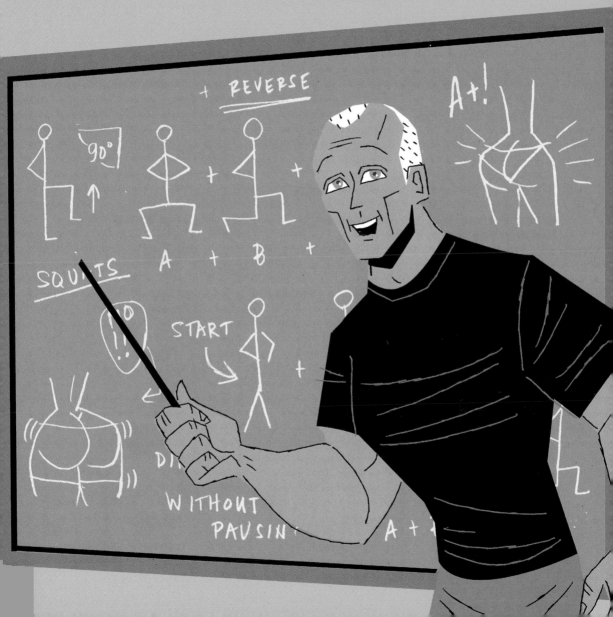

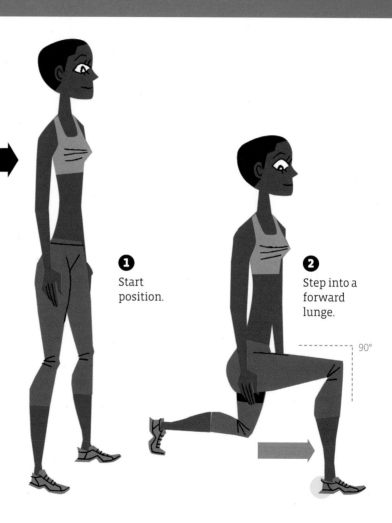

COMBO 1

Forward and reverse lunge

❶ Start position.

❷ Step into a forward lunge.

90°

Now that you've mastered the basics, let's mix it up to maximize results. Doing these exercises in sequence creates a powerful burn.

You should always be making right angles. Drop anchor in your heels.

3

Without pausing, move directly into a reverse lunge.

90°

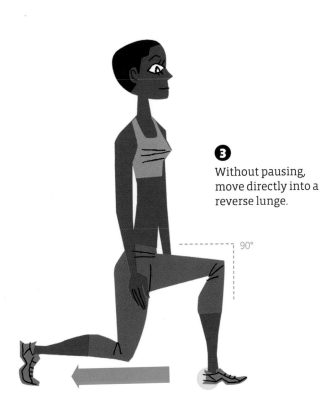

COMBO 2

Reverse crossover lunge into lateral lunge

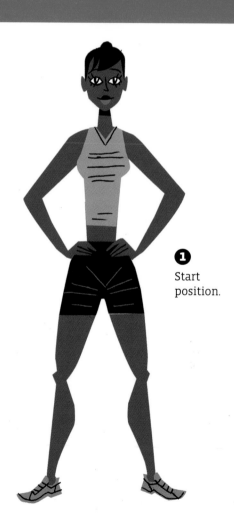

❶
Start position.

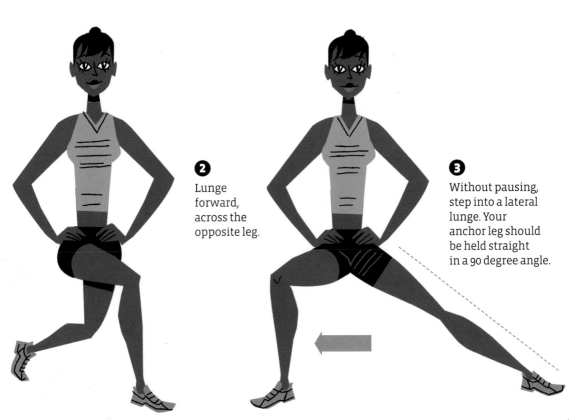

2
Lunge forward, across the opposite leg.

3
Without pausing, step into a lateral lunge. Your anchor leg should be held straight in a 90 degree angle.

③ COMBOS

COMBO 3

Reverse
lunges into
high kicks

1
Start
position.

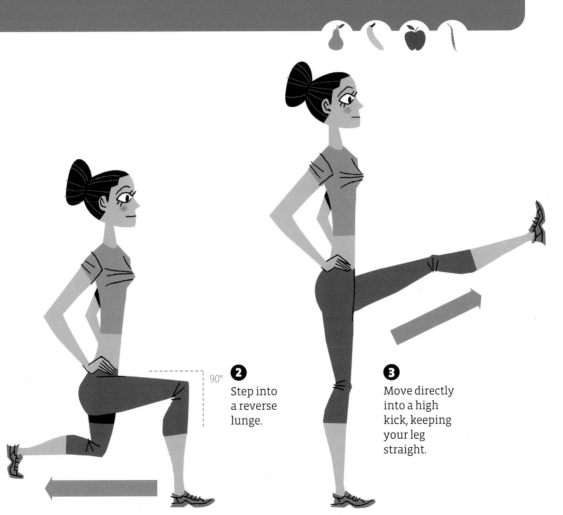

❷ Step into a reverse lunge.

90°

❸ Move directly into a high kick, keeping your leg straight.

47

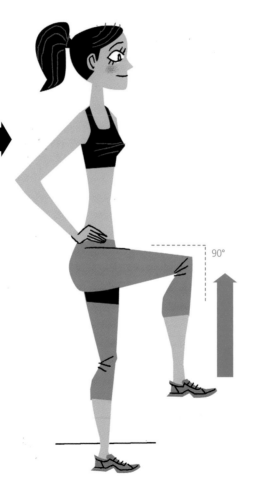

③ COMBOS

COMBO 4

One legged squats into seesaws

90°

1 Stand on one leg and bring the opposite knee up to a right angle.

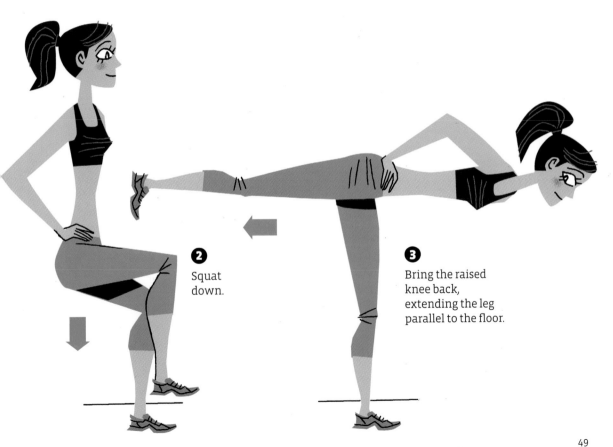

2

Squat down.

3

Bring the raised knee back, extending the leg parallel to the floor.

49

4
the
STRETCHES

4 STRETCHES

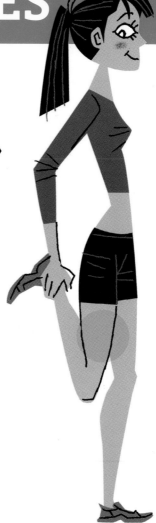

Quads

Standing with your feet together, bend one leg at the knee. Reach back to take hold of your ankle, pulling gently until you feel a stretch down the front of your thigh. For extra stretch, press your hips forward.

Stretching is great, it's important for keeping limber and for preventing injury, but also, it's a great time to reconnect your mind and your body: did you do what you wanted to do?

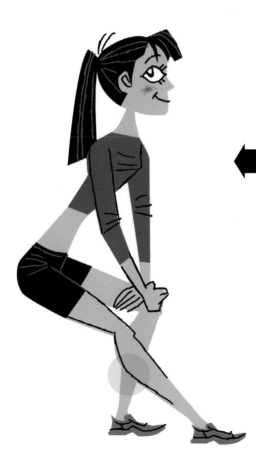

STRETCH 2

Hamstring

Stand with one foot forward, anchored by your heel. Allow your toes to point skyward. Bend your knees into a sitting position until you feel a soft tug on the back of your leg. To feel the stretch more deeply, sit more deeply into the stretch.

STRETCH 3

Inner thigh and outer butt
Cross one leg in a V over the other and sit back so your leg forms a triangle.

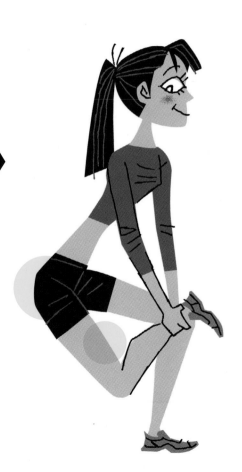

Be careful and listen to your body. Don't overdo it—there are few things more debilitating than a pulled hamstring or a strained glute.

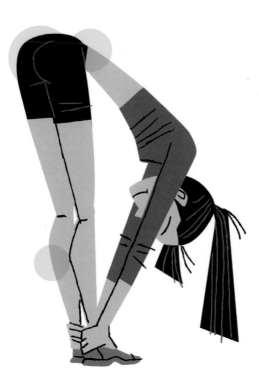

STRETCH 4

The whole caboose

Bend at the waist, reaching as far down as you can. This could be your calves, your ankles—or ideally— the floor. You'll know your own limit as you feel the stretch from your lower back through your butt, right down to your toes.

5
CARDIO

A good cardio routine is the perfect complement to a butt blast!

Cardiovascular exercise can help raise your metabolism, and it can help burn off unwanted, extra weight that's standing between you and your dream derriere.

My favorite overall cardio exercise is the rowing machine: minute for minute, you burn the most calories while working your legs, butt, core, arms and back. That machine is a calorie incinerator! But I'm an equal opportunity sweater: there's no reason you can't get a great workout on any of the cardiovascular machines at your local gym. (Or, for that matter, running up and down that hill in your neighborhood, or biking to work instead of driving...)

As with everything I prescribe, your exercises are not one size fits all. For boyish figures, a combination of an elliptical machine and a bike is great for developing your hips and rears.

Flat-bottomed girls are going to do an energizing turn on the treadmill, varying speed and intensity. (The higher the incline, the more emphasis there is on your butt...) Whatever the regime, you need to commit to doing it a few times a week to really see results. And you need to commit to full workouts: try to stick at whatever you're doing for 45 minutes. You can up the intensity as you get stronger and more fit, but really block the time out of your schedule and dedicate yourself to the process.

As with all of my programs, this is meant as a guide. Feel free to personalize (so as long as you're not cutting back) to suit your level of fitness, and what equipment you have access to. So long as you're pushing as hard as you can push, take some latitude to adjust, to bump up as necessary. The most important thing is that you are never disconnected from your body. You know the difference between getting sweaty and merely damp.

MPRE is MAXIMUM PERCEIVED RATE OF EXERTION.

MPRE is a subjective gauge of how hard you're pushing yourself. Sure, there are devices and gadgets that tell you how hard you're working, but I'm going to ask you to gauge yourself, on a scale from one to ten. Here are the questions to ask yourself:

1. *Am I sweating?*
2. *Do I feel my heart rate increasing?*
3. *Could I maintain a conversation during this workout?*
4. *Am I feeling a muscle burn?*

When you're first starting out, allow yourself a little latitude.

As you get more exercise proficient, turn that dial up. It's when you start pushing your limits that you'll see great results.

You need to reach inside yourself. You're setting your internal speedometer, you know when you're reaching your own personal red zone.

DON'T

To those of you that load up for your cardio session with PDA's, magazines, and the latest gossip rag—you know who you are—take note. As I say with my workouts, make them mindful and make them efficient and effective. The same is true for cardio.

I want you to sweat. I want you to feel your butt engaged. I want you to feel every day that you're pushing yourself to the limit and beyond. No less will do if you're after the perfect butt.

PRESCRIPTIONS

the apple & pear

Big all over carries weight from her knees to her neck, and everywhere in between. And her bottom? A real 911 situation. It's big, it's proud, and it's sliding down her thighs. The pear's got it going on—just maybe a little too much of it.

THE PRESCRIPTION

First and foremost, in both situations we need to reduce your overall weight. And be prepared to up the intensity: no strolling, no chatting, no checking messages on your Blackberry. Get ready to trade those tabloids for a very absorbent towel! You're going to need it.

Start out on the elliptical machine: most have a pre-set fat burning program. Use it! Work up a sweat, get out of breath, and stay on there for anywhere between 30 and 45 minutes a pop.

When this starts feeling easy, it's time to attack. Here's your plan:

Two 250 meter sprints on the rowing machine, alternating with 5 minutes on the gauntlet at level 6 or 7 in between.

Repeat this circuit twice.

If you're not huffing or puffing, how about another round?

elliptical:
30-45 minutes

+

rowing machine:
1000 meter sprints

+

the gauntlet:
10 minutes

⑤ PRESCRIPTIONS

boyish

You're sexy and you're beautiful, yes, but you've got no definition on either side. Your right and your left sides are perfectly parallel. What you want is a little oomph.

THE PRESCRIPTION

For boyish figures, I recommend the elliptical runner. The stride here resembles a traditional runner's stride, but the machine eliminates any pounding on your knees and back. To start, go for thirty minutes at a time.

When this is no longer challenging, get on two wheels! Find a great spinning class at your local gym or get outside, get on your bike and ride! Ride far and don't shy away from hills. Cycling will build up quadriceps and hips and butt in a toned and proportionate way.

When that gets too easy (it will!), add the versaclimber to your routine, making sure to stick your butt out and keep your abs tight. It's a really effective way to create, while shaping, the perfect butt.

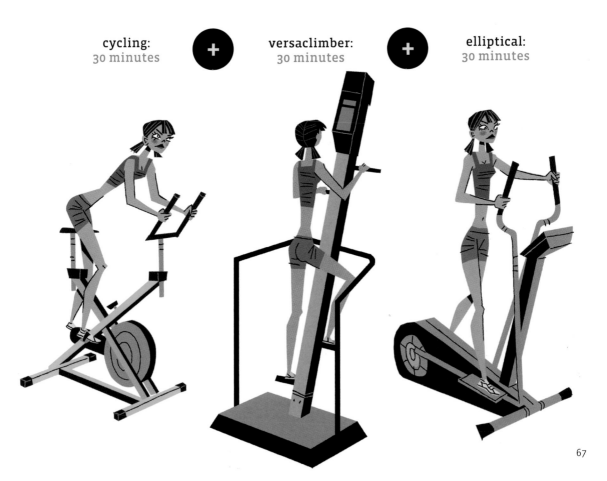

cycling:
30 minutes

+

versaclimber:
30 minutes

+

elliptical:
30 minutes

PRESCRIPTIONS

flat-bottomed

The butt may as well be a continuation of your back. And where's the fun in that? We want your butt to stand out.

THE PRESCRIPTION

Start out by running on the treadmill, at a two percent incline. The higher the incline the more the weight shifts back to your heels and focuses on your butt. As far as the speed is concerned, you need to determine what you can manage. My formula for MPRE should help you to determine a challenging yet safe and effective gait. Start with one to two miles on the treadmill, and when that gets too easy, move to speed intervals on the treadmill, varying the percentage of incline and the speed in one minute intervals.

treadmilll:
2% incline, 6 mph

+

treadmilll:
4% incline, 7 mph

6

FOOD

All body types need to learn the ABC's of nutrition.

Chocolate, cheese and all things fried are now considered splurges, eaten only on special occasions. But whether you're trying to add or subtract, or just lift, tone and tighten, you'll be eating the same delicious, nutritious, functional and easy to prepare foods.

I'm not a huge advocate of dairy, but in moderation it (like most things) is okay. Stick to fat free plain yogurt (I like the strained Greek variety, it's lower in sugar), or skim milk. My favorite is Fage Total 0%, with a few blueberries on top for flavor. It's nutrient rich, full of calcium and vitamins D and C. It's also and anti-oxidant.

Fruit is loaded with vitamins, but it's also loaded with sugar. So please limit your fruit intake. The following fruits will be allowed, but only before 2:00 pm: berries (blue, black, straw), kiwi, apples, and the

occasional grapefruit. One portion of fruit a day is enough, for everyone. So if it's yogurt and berries in the morning, you're not going to have two or three more fruits throughout the day.

When it comes to carbs, they're not verboten: bodies like Kristina and Joyce have much more latitude with healthy carbs such as quinoa, lentils, beans, steel-cut oatmeal and brown rice every now and then.

And yeah, that chocolate and cheese? I'm not kidding: if you want a great ass, step away from the cheese.

It's true. Just is. I'm sorry.

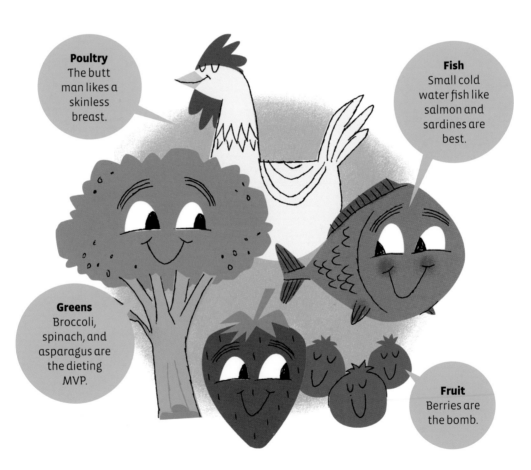

Poultry
The butt man likes a skinless breast.

Fish
Small cold water fish like salmon and sardines are best.

Greens
Broccoli, spinach, and asparagus are the dieting MVP.

Fruit
Berries are the bomb.

I believe in five meals a day: every three hours. I can't overemphasize the importance of breakfast, of consuming the bulk of your calories and carbs before 2 pm, and sticking to my healthy snack options. When setting out on your own butt project, keep in mind, there may be

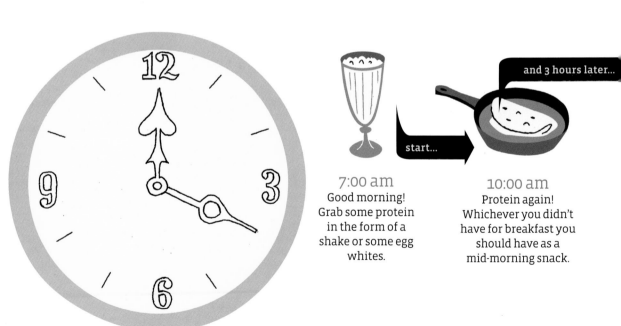

7:00 am
Good morning! Grab some protein in the form of a shake or some egg whites.

start...

and 3 hours later...

10:00 am
Protein again! Whichever you didn't have for breakfast you should have as a mid-morning snack.

some potholes along the way. Don't despair. It's happened to the tightest, roundest, most prominent butts out there. Remember to stay the course, and sweat harder the day after the occasional slice of pizza , or wedge of cheese.

1:00 pm
Take a power lunch: choose a lean protein (chicken, turkey, tuna) and mix it with some greens. You can also choose a healthy, starchy grain at lunch time: a slice of whole grain bread, a cup of steamed brown rice.

snack time...

4:00 pm
Snack on a protein: a handful of almonds is always a good choice.

finish!

7:00 pm
For dinner, go for the same idea as lunch: lean protein, green vegetables, but this time, skip the starchy carb.

STICKING TO IT

AT HOME

Get any and all food demons right out of your house. Can't resist cookies and chips? Don't buy them! Your home should be the safest place for keeping to your new-body meal plan, stocked with lean proteins and healthy vegetables and grains.

Use half of your lunchtime for a power walk around the block. Crummy weather? A series of squats at your desk can only help....

STICKING TO IT

OUT TO EAT

I've been known to take my clients out to eat in order to teach them how best to navigate a menu. It is possible! Call the restaurant ahead of time (or check on-line) to look at the menu. It's easier to make sensible choices in advance. Then banish bread, and stick to the smart choice you made before you got hungry.

I'm no sadist. Enjoy yourself! Put an umbrella in that drink (please, please limit it to one!!), kick back, and rock that new bikini. You've earned it!

Welcome to your
new assitude...

Congratulations! If you've followed this manual closely, you are sitting right now atop a pretty spectacular butt! Get out there and rock some skinny jeans, some slinky dresses, some stringy bikinis—what is most important to me is that you feel great about yourself and that you have a great time in your new self. I want to teach you a word that should sum up how you're feeling: it's ASSITUDE™. When you walk down the street, on the beach, or in your bedroom, it's all about a perky butt. You got it, so get out there and flaunt it.

If you've liked this manual, stay tuned for more in the series—Shoulders, Back and Arms; and Legs and Abdominals.